Piss Off

Hilarious Sweary Coloring Book for Fun & Stress Relief

By

S.B. Nozaz

Copyright © 2016 by S.B. Nozaz

All rights reserved worldwide. No part of this publication may be reproduced or distributed in any form or by any means, mechanical, electronic or stored in a retrieval or database system, without written permission from the copyright holder.

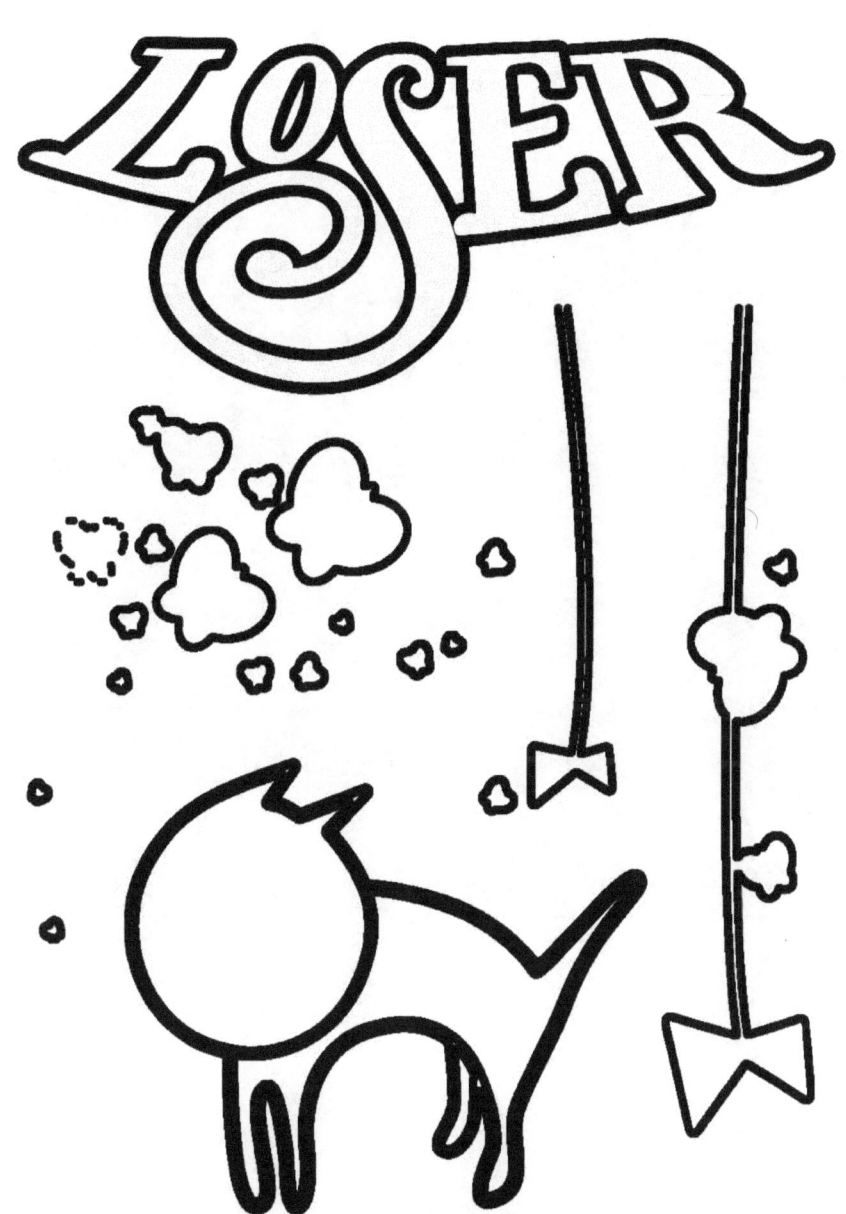

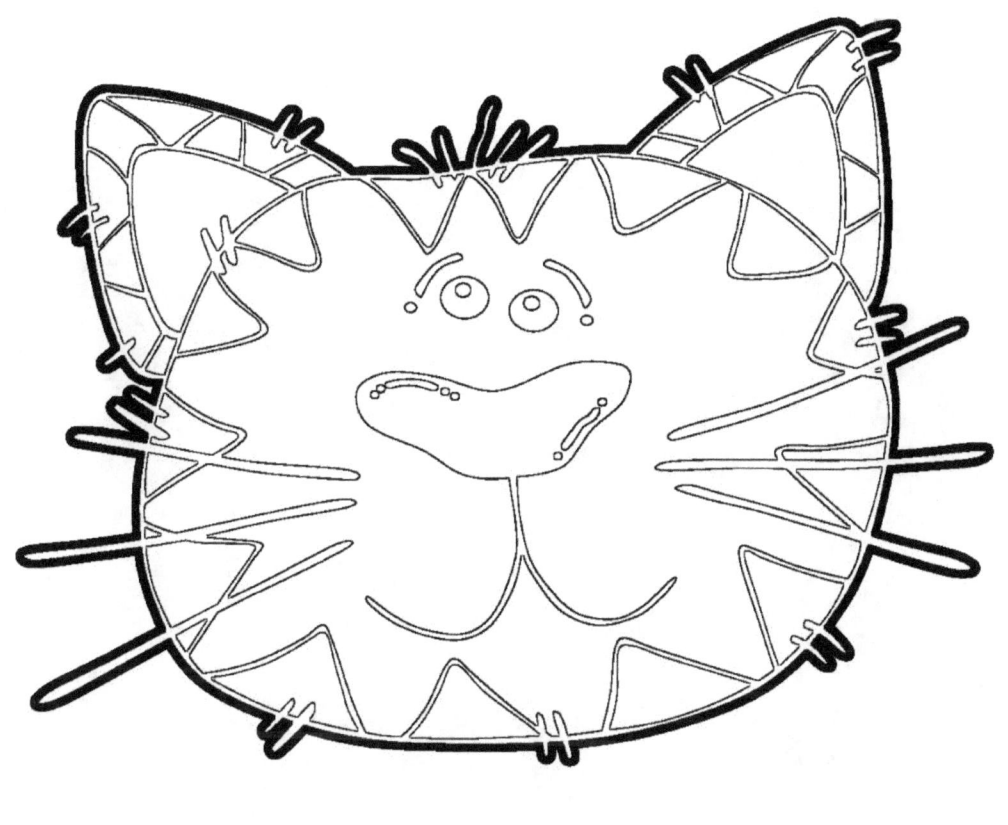

FUCKERPALOOZA

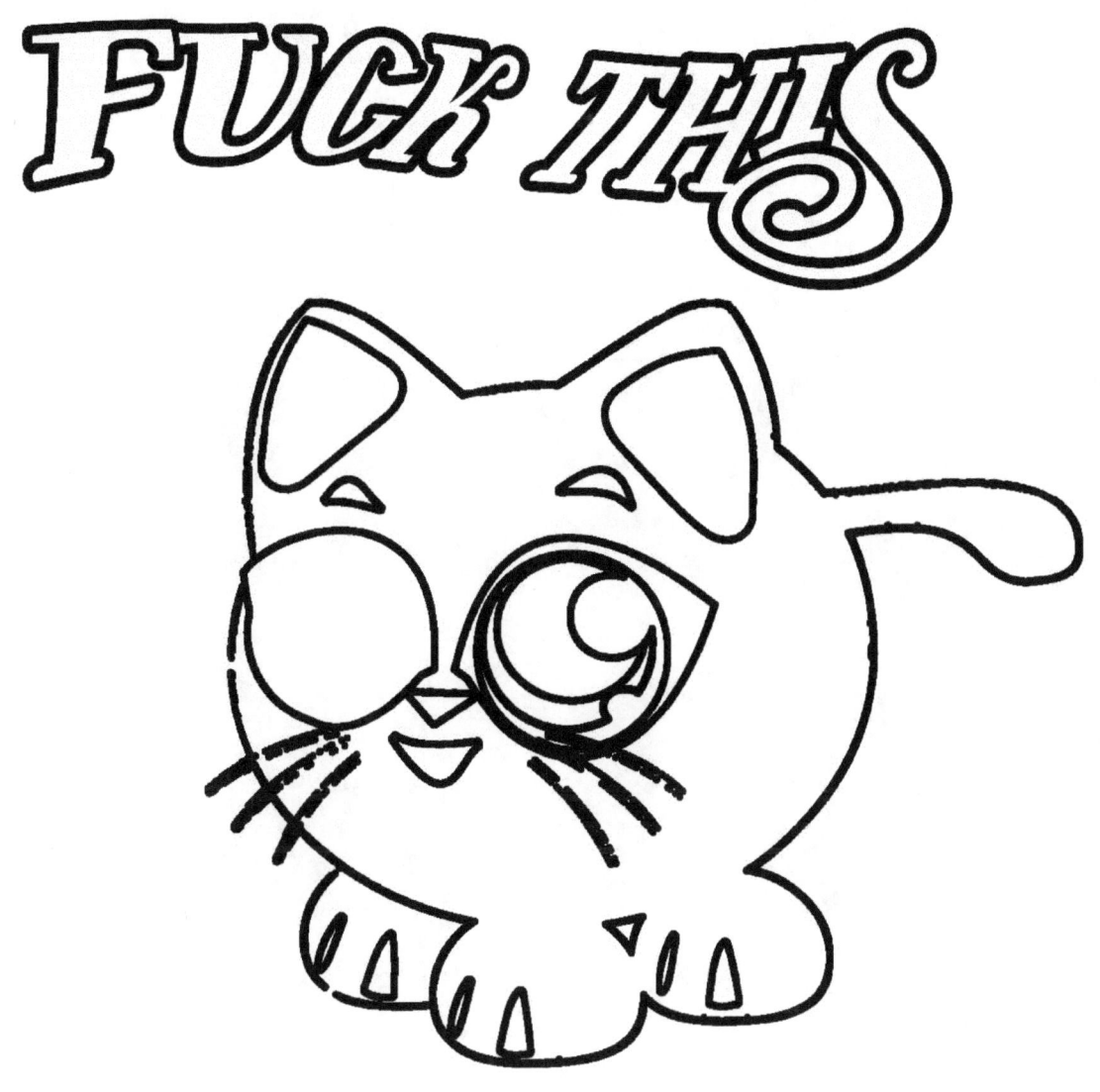

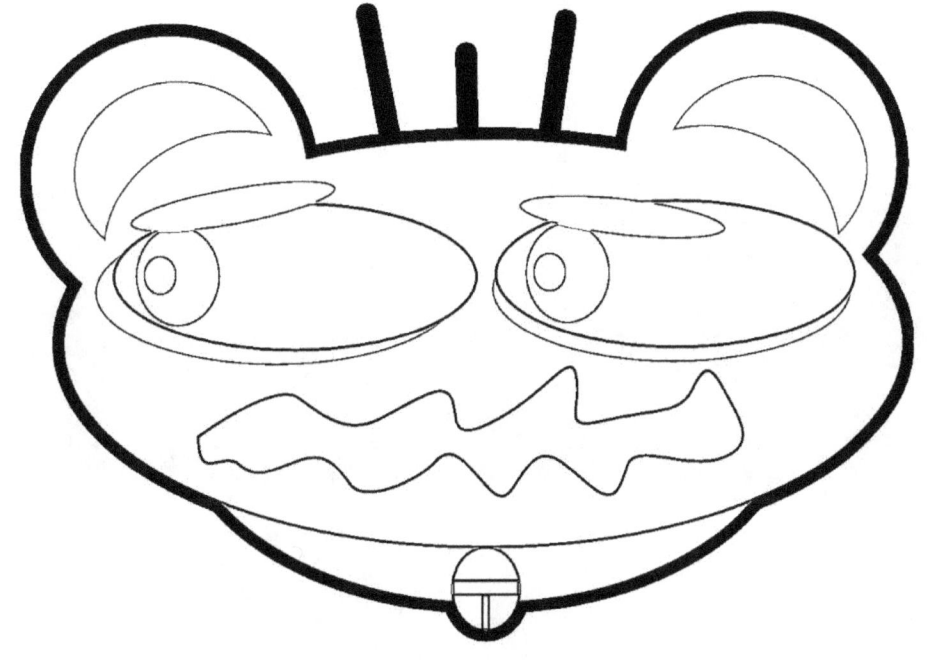

OLD FART

CALM YOUR TITS

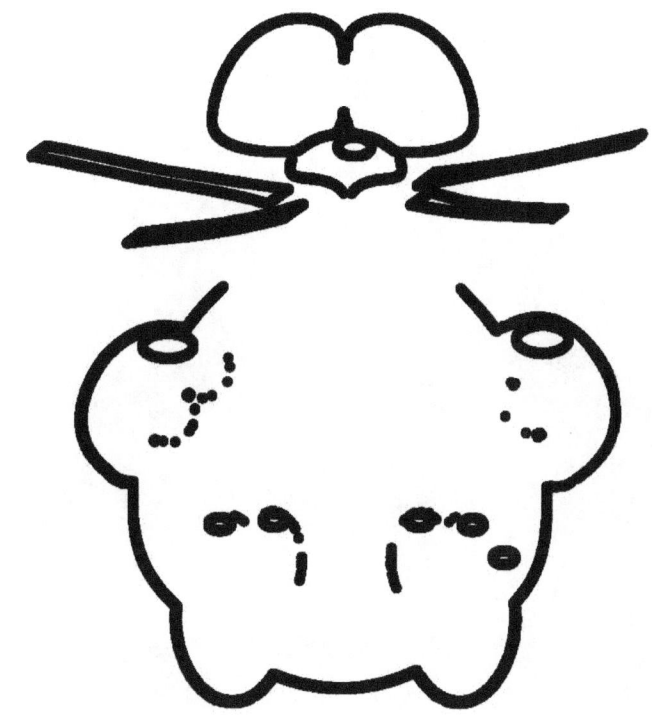

MOTHERFUCKER

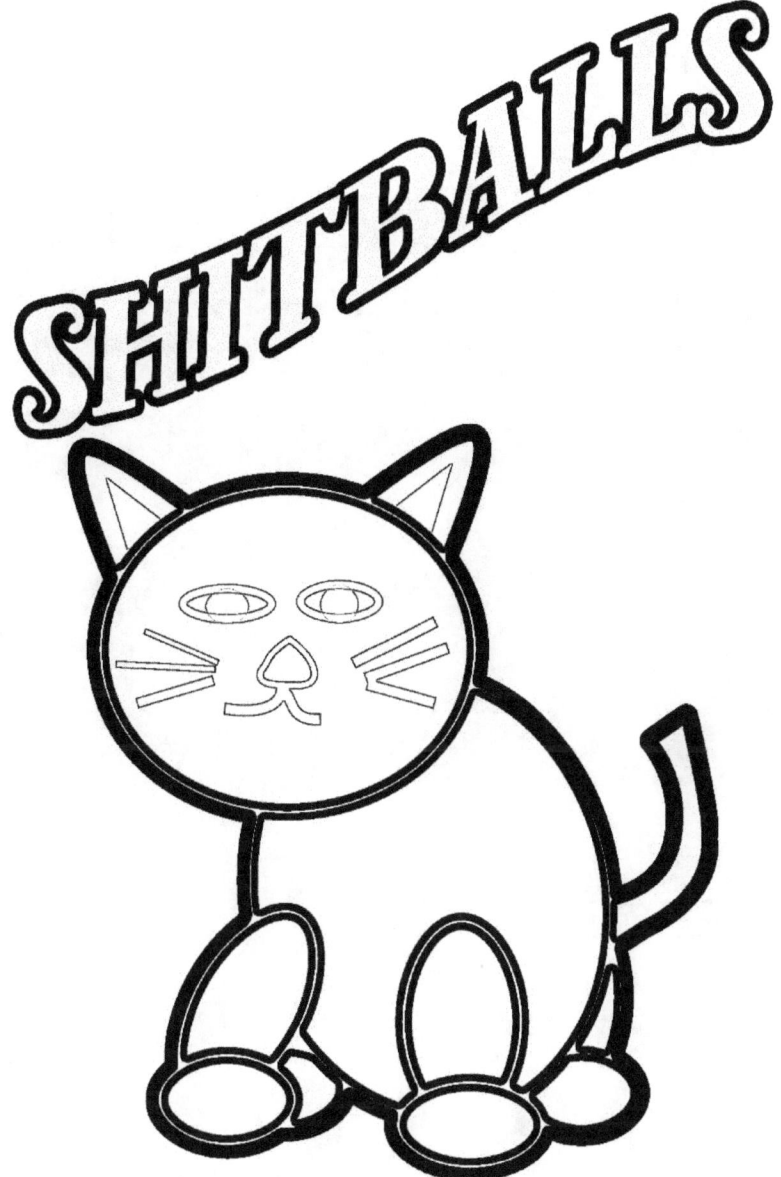

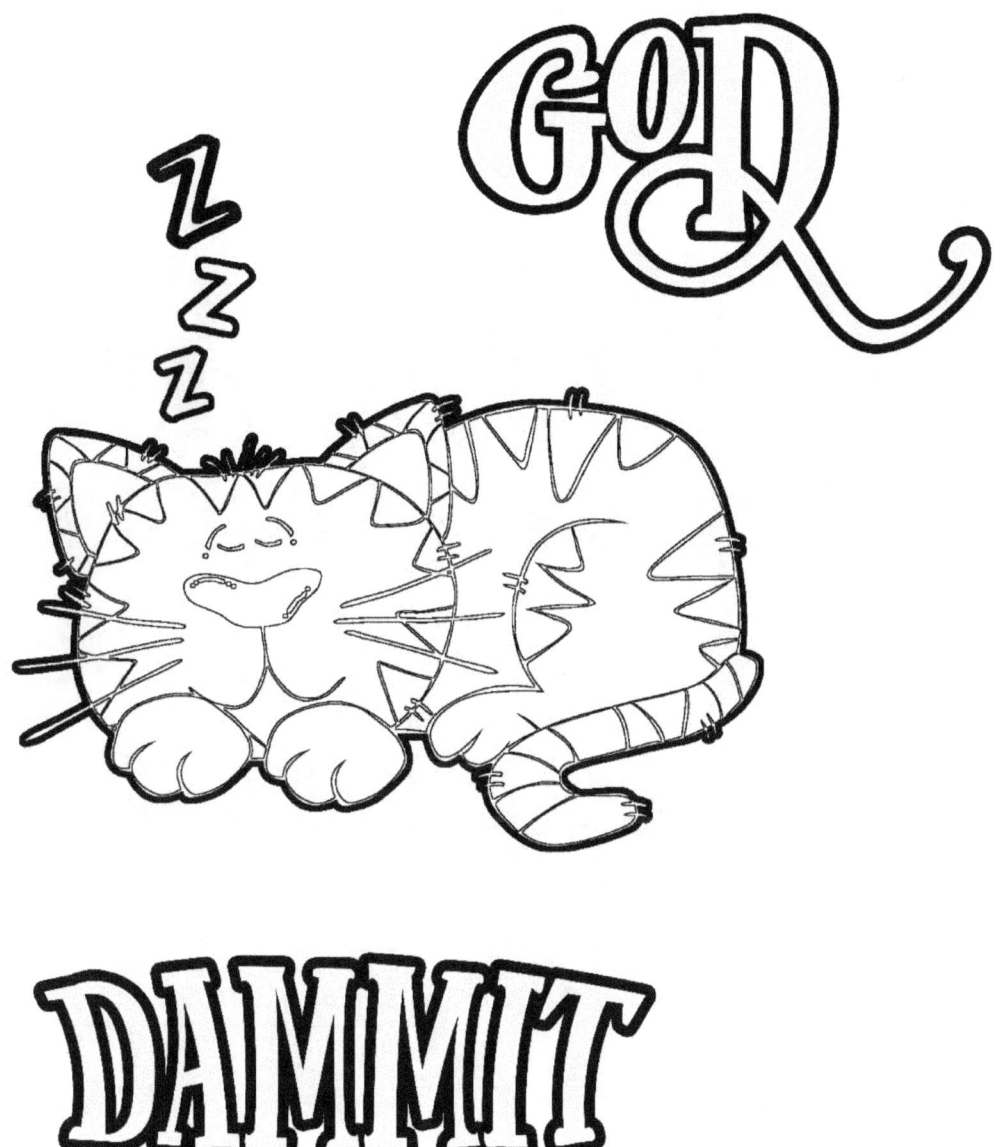

DAMN YOU

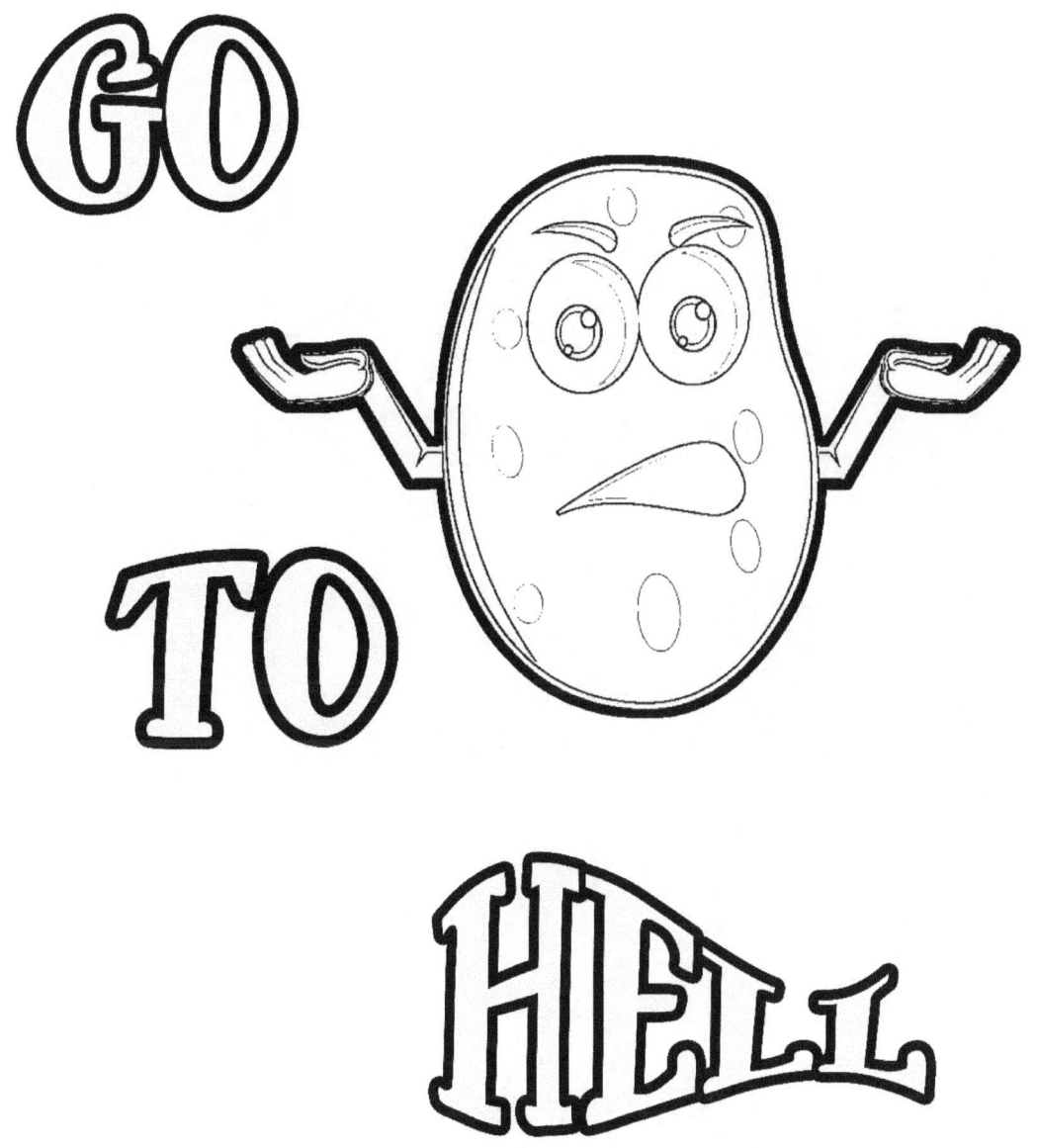

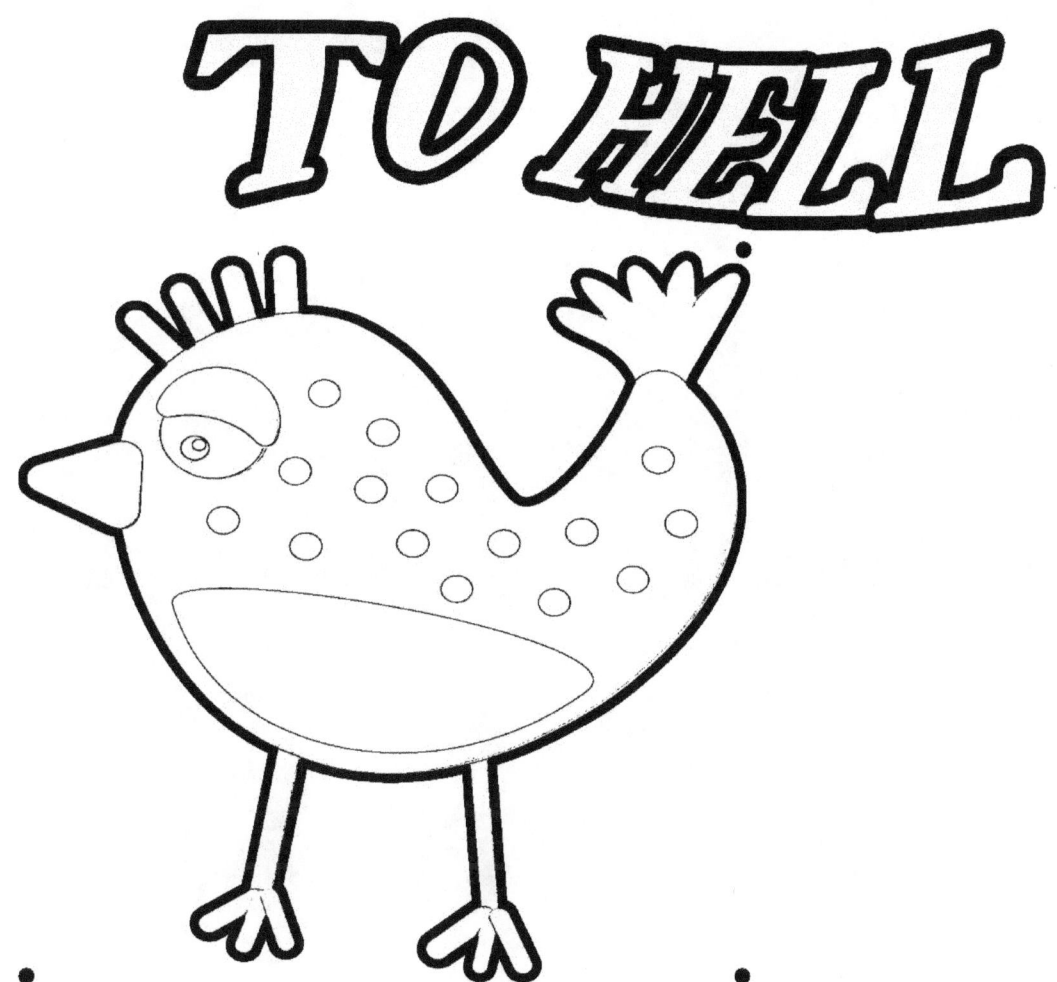

EAT SHIT

DAMN

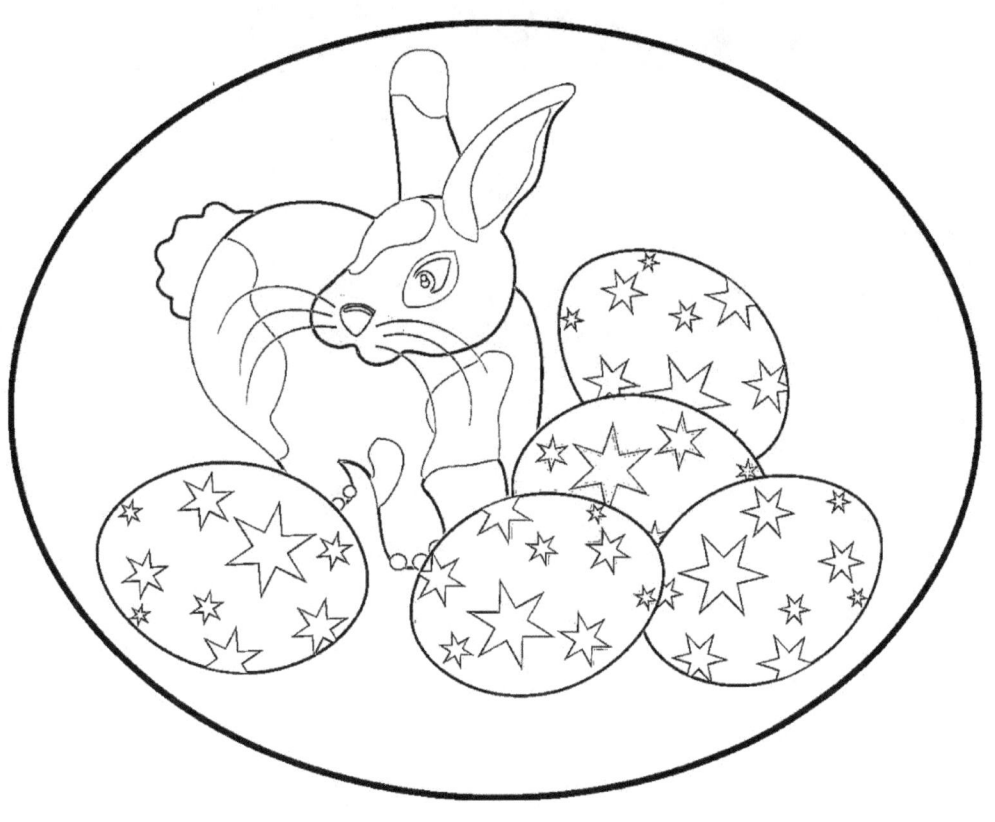

YOU ARE

SHIT

OUT OF LUCK

SHIT BRAIN

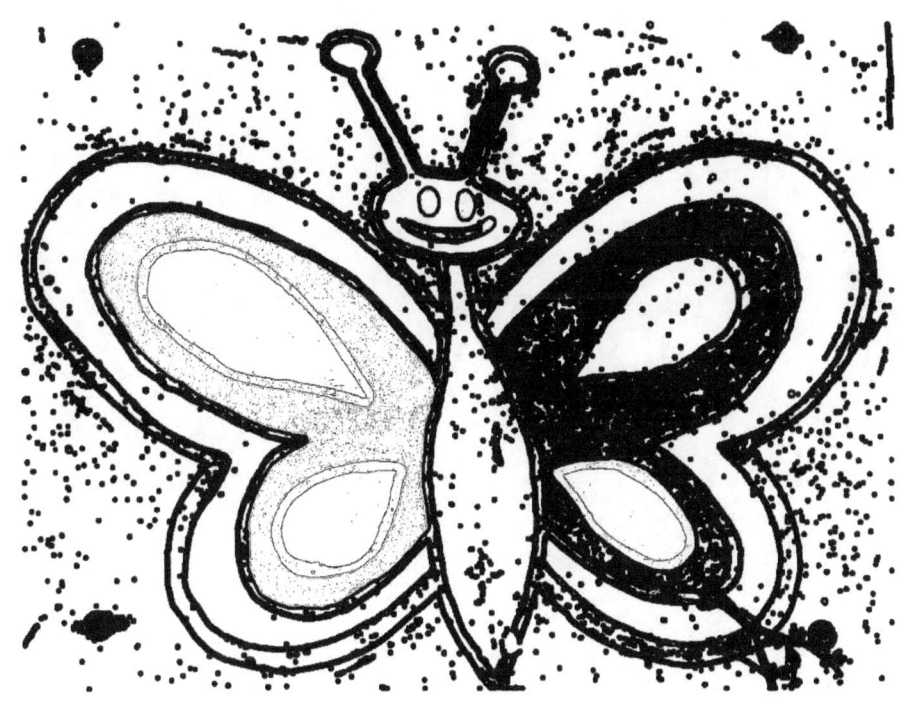

WHAT A PUSSY

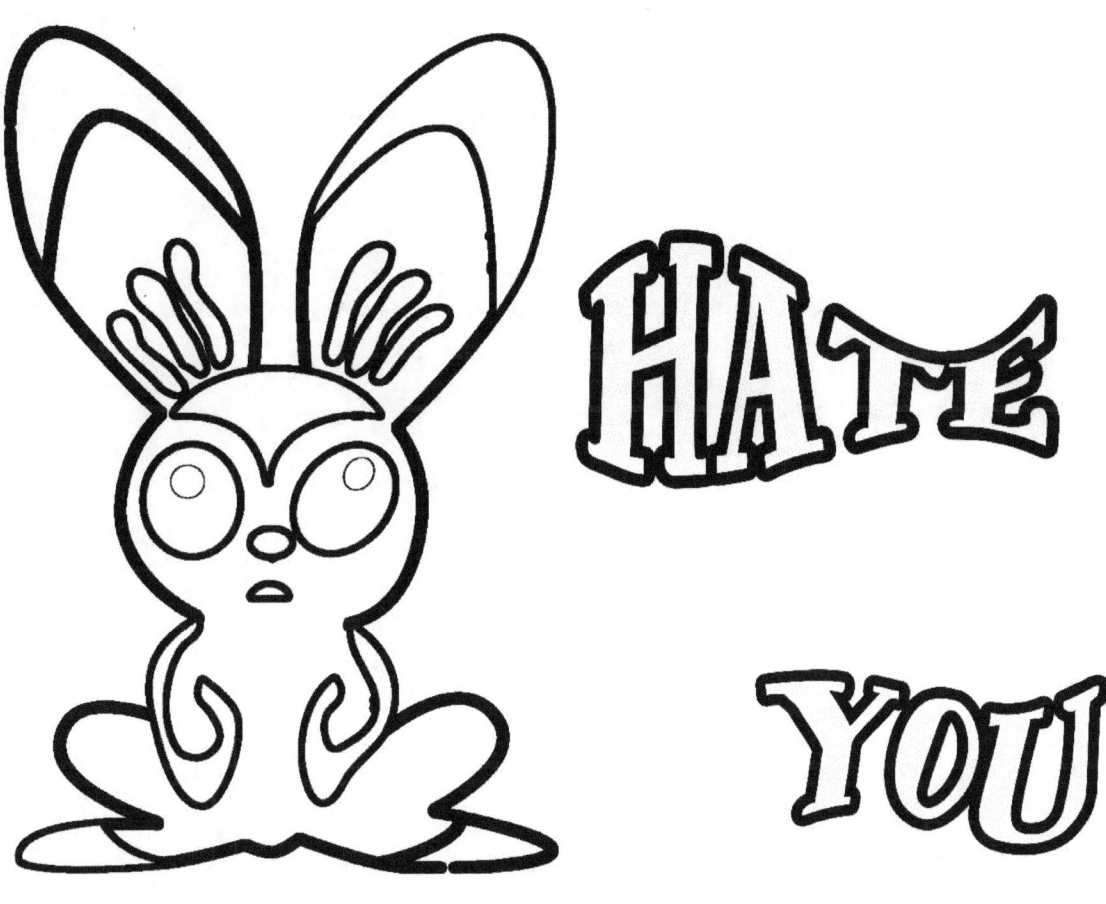

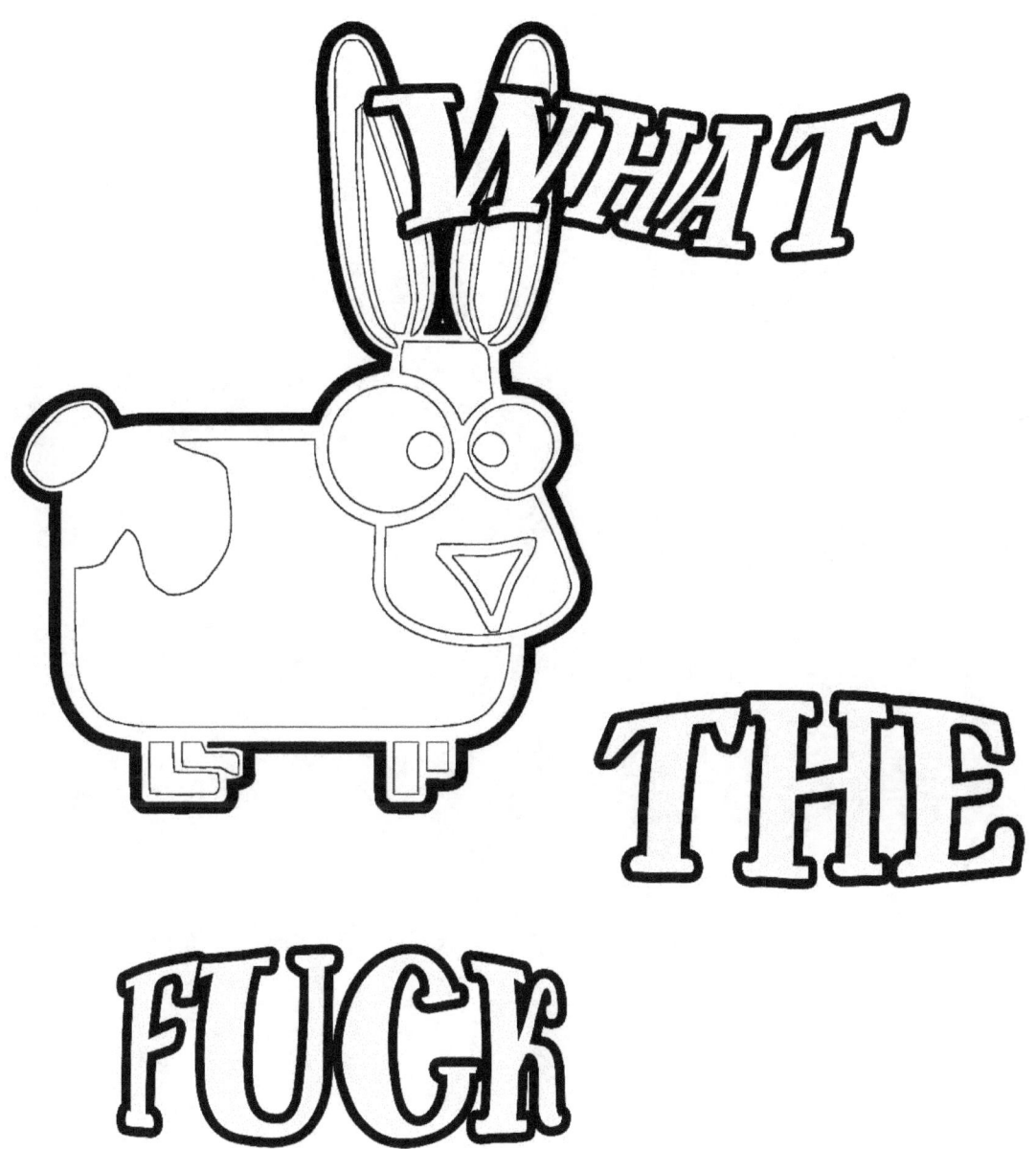

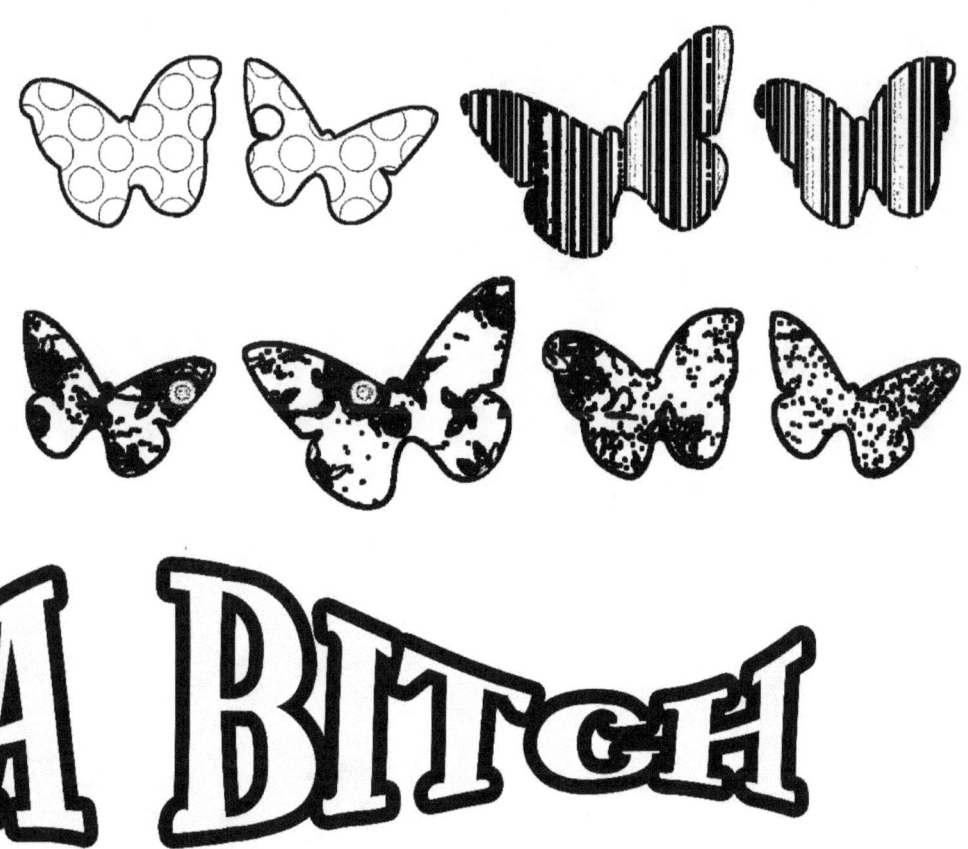

JERK

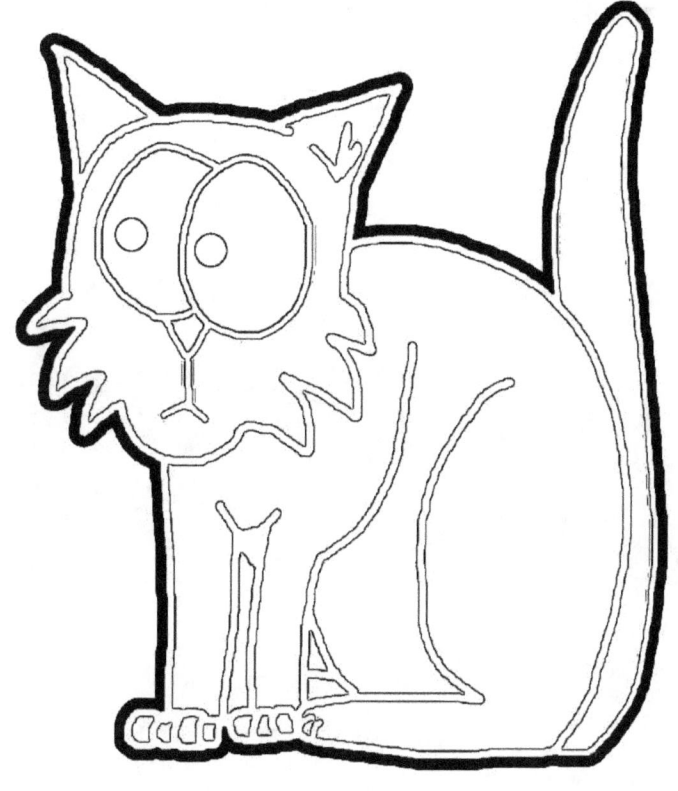

ASSHOLE

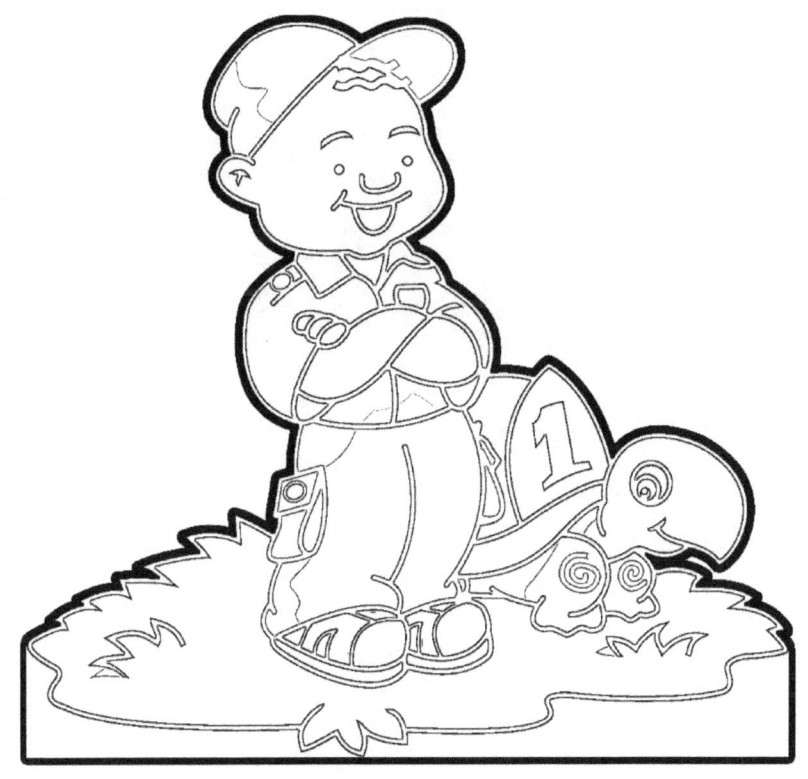

Note

www.ingramcontent.com/pod-product-compliance
Lightning Source LLC
Chambersburg PA
CBHW080635190526
45169CB00009B/3402